SUNDAY DOOR POSTS

Timothy R. Botts

SHEED & WARD

The title *Sunday Doorposts*
is adapted from *Doorposts,*
also by Timothy R. Botts,
published by Tyndale House Publishers.

Sheed & Ward TM is a service of
National Catholic Reporter Publishing, Inc.

Library of Congress Catalog Card Number 87-6177

ISBN 1-55612-078-8

Published by Sheed & Ward
115 E. Armour Blvd. P.O. Box 414292
Kansas City, MO 64141-0281

To order, call (800)821-7926

that you may
tell your children
and grandchildren
that you may tell your
children and
grandchildren
that you may tell your children
and grandchildren
that you may tell your children
and grand children that you
may tell your children and grandchildren
that you may tell your children and
grandchildren

FROM EXODUS 10:2 NIV

CREATE IN ME A PURE HEART O GOD,

AND RENEW A STEADFAST SPIRIT WITHIN ME

PSALM 51 : 10

NIV

Serve
the Lord
with gladness,
Come before
him
with joyful
songs.

Psalm
100:2
NIV

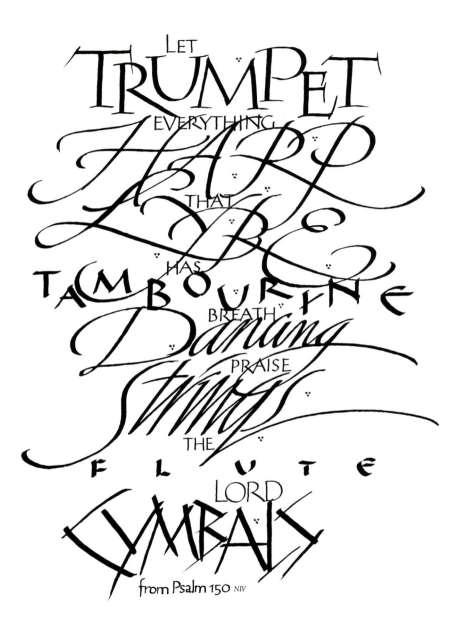

LET
TRUMPET
EVERYTHING
HARP
THAT
LYRE
has
TAMBOURINE
BREATH
Dancing
PRAISE
Strings
THE
FLUTE
LORD
CYMBALS

from Psalm 150 NIV

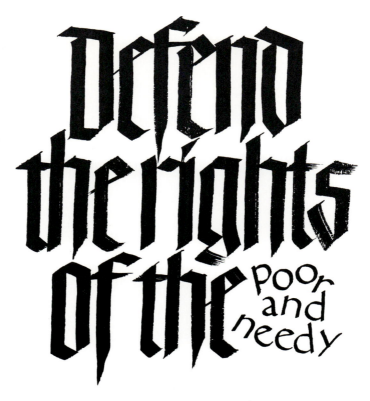

PROVERBS 31 : 9 b *NIV*

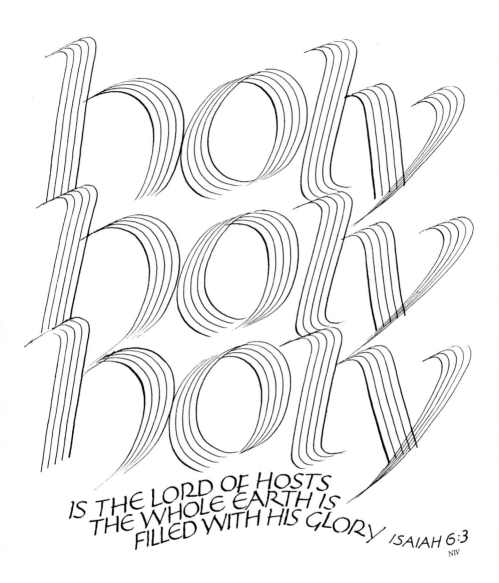

holy
holy
holy

IS THE LORD OF HOSTS
THE WHOLE EARTH IS
FILLED WITH HIS GLORY ISAIAH 6:3
NIV

LIFT YOUR EYES AND LOOK TO THE HEAVENS: WHO CREATED ALL THESE? HE WHO BRINGS OUT THE STARRY HOST ONE BY ONE, AND CALLS THEM EACH BY NAME · FROM ISAIAH 40 : 26

NIV

Let him
who
boasts
boast
about
this

FROM *Jeremiah 9:24* NIV

that he
understands
and knows me,
that I AM THE LORD,
who exercises kindness,
justice and righteousness
on earth,
for in these I delight.

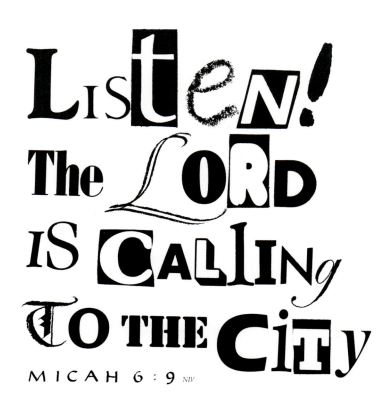

LISTEN! The LORD IS CALLING TO THE CITY

MICAH 6:9 NIV

For the earth will be filled with the knowledge
of the glory of the Lord, as the waters cover the sea
For the earth will be filled with the knowledge
of the glory of the Lord as the waters cover the sea
For the earth will be filled with the knowledge
of the glory of the Lord as the waters cover the sea
For the earth will be filled with the knowledge
of the glory of the Lord as the waters cover the sea
For the earth will be filled with the knowledge
of the glory of the Lord as the waters cover the sea

HABAKKUK 2:14
NIV

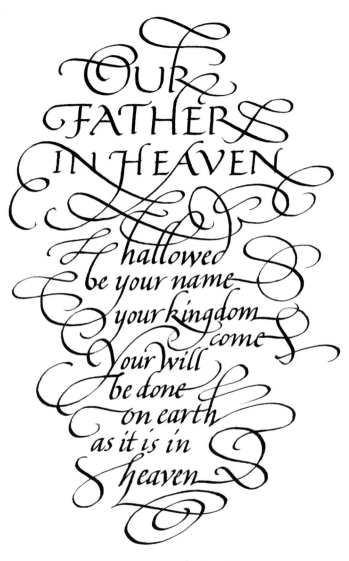

OUR
FATHER
IN HEAVEN

hallowed
be your name
your kingdom
come
Your will
be done
on earth
as it is in
heaven

MATTHEW 6: 9-10 NIV

WHAT IS WHISPERED IN YOUR EAR PRO CLAIM FROM THE HOUSE TOPS

from MATTHEW 10 : 27 NIV

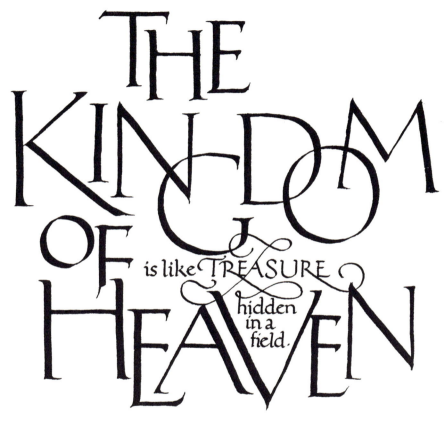

THE
KINGDOM
OF
HEAVEN
is like TREASURE
hidden in a field.

MATTHEW 13:44 NIV

"WHO DO YOU SAY I AM?" SIMON PETER ANSWERED, "YOU ARE THE CHRIST, THE SON OF THE LIVING GOD." JESUS REPLIED, "BLESSED ARE YOU, SIMON SON OF JONAH, FOR THIS WAS NOT REVEALED TO YOU BY MAN, BUT BY MY FATHER IN HEAVEN. AND I TELL YOU THAT YOU ARE PETER, AND ON THIS ROCK I WILL BUILD MY CHURCH, AND THE GATES OF HADES WILL NOT OVERCOME IT

FROM MATTHEW 16:15-18 NIV

If you have faith
as small as a mustard seed
you can say to this mountain,
"Move from here to there"
and it will move,
Nothing will be
impossible
for you,

Matthew 17:20
NIV

And Jesus said,
"I tell you the truth,
unless you change
and become like
little children,
you will never
enter the kingdom
of heaven."

MATTHEW 18:3 NIV

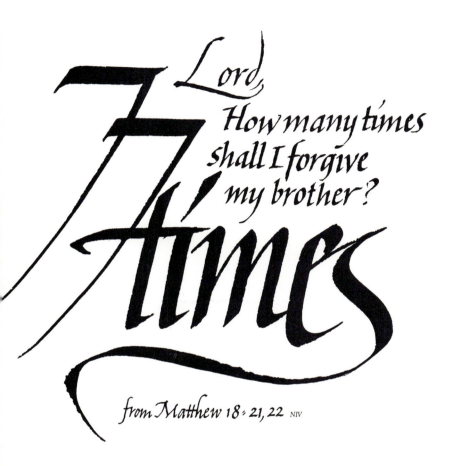

77 Times

Lord, How many times shall I forgive my brother?

from Matthew 18 : 21, 22 NIV

For this reason a man will leave his father and mother and be united to his wife, And the two will become one flesh. So they are no longer two, but one. MATT 19:5 verse 6 ∴ Therefore what God has joined together, let man not separate. NIV

Hosanna
to the
Son of David
Blessed is he
who comes
in the name
of the Lord
Hosanna
in the
highest

MATTHEW 21 : 9 NIV

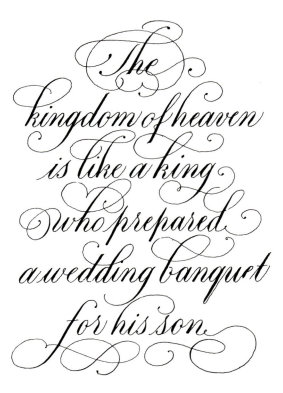

The kingdom of heaven is like a king who prepared a wedding banquet for his son.

MATTHEW 22 : 2

NIV

Love the Lord your God with all your

heart

and with all your

soul

and with all your

mind.

Matthew 22:37 NIV

I was hungry and
you gave me something to eat,
I was thirsty and
you gave me something to drink,
I was a stranger and
you invited me in,
I needed clothes and
you clothed me,
I was sick and
you looked after me,
I was in prison and
you came to visit me.
MATTHEW 25:35-36 NIV

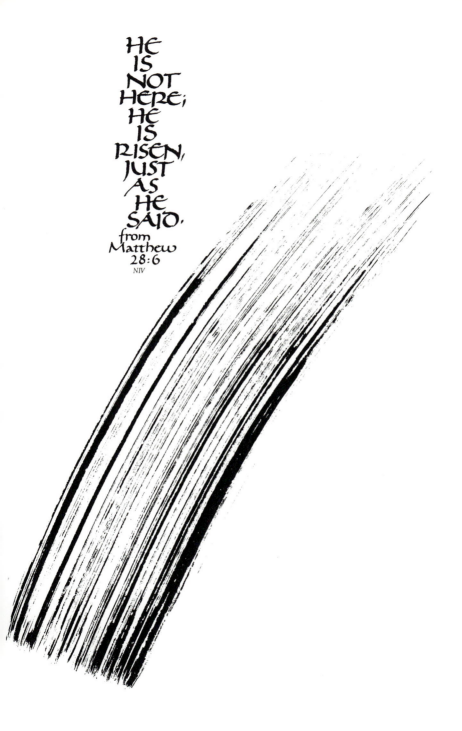

HE
IS
NOT
HERE;
HE
IS
RISEN,
JUST
AS
HE
SAID.
from
Matthew
28:6
NIV

"Abba, Father"

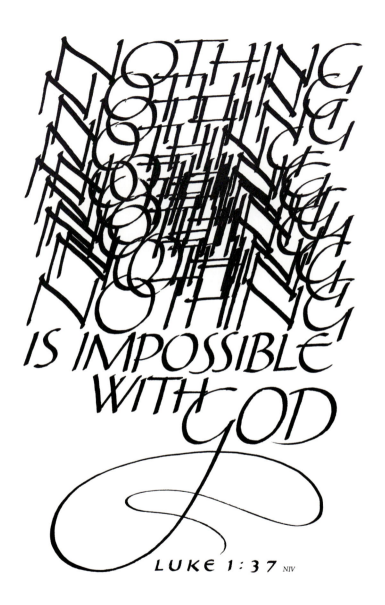

NOTHING
NOTHING
NOTHING
NOTHING
NOTHING
NOTHING
IS IMPOSSIBLE
WITH GOD

LUKE 1:37 NIV

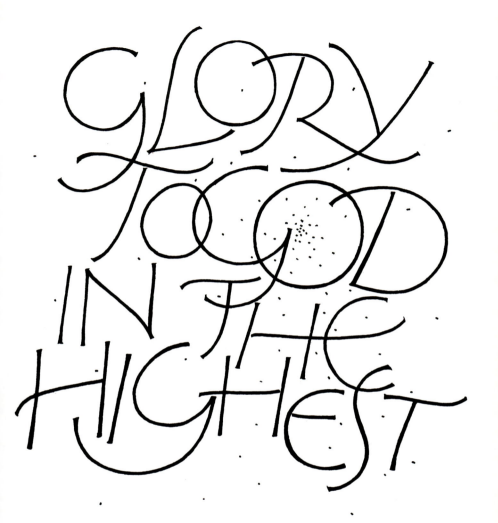

GLORY
TO GOD
IN THE
HIGHEST

AND ON EARTH PEACE TO MEN
ON WHOM HIS FAVOR RESTS
LUKE 2:14 NIV

IF + ANYONE
WOULD + COME
AFTER + ME
HE + MUST
DENY + HIMSELF
AND + TAKE + UP
HIS + CROSS
DAILY + AND
FOLLOW + ME

LUKE 9:23 NIV

all men will know that you are my disciples if you love one another. JOHN 13:35 NIV

THEY DEVOTED
THEMSELVES
TO THE APOSTLES'
TEACHING, AND TO
THE FELLOWSHIP,
TO THE BREAKING
OF BREAD AND
TO PRAYER

ACTS 2:42 NIV

BELIEVERS TOGETHER

with glad and sincere hearts from ACTS 2 : 44 & 46 NIV

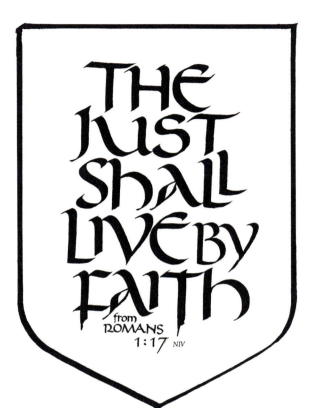

THE JUST SHALL LIVE BY FAITH

from ROMANS 1:17 NIV

I AM CONVINCED THAT
NEITHER **death**
NOR *life,*
NEITHER
Angels
NOR **DEMONS,**
NEITHER THE PRESENT
NOR THE *FUTURE,*
NOR ANY POWERS,
NEITHER HEIGHT
NOR DEPTH,

NOR ·A·N·Y·T·H·I·N·G· E·L·S·E·
·I·N· A·L·L· C·R·E·A·T·I·O·N·
WILL BE ABLE TO SEPARATE US
FROM THE *love of God*
THAT IS IN
CHRIST JESUS
OUR LORD
ROMANS 8:38 – 39 *NIV*

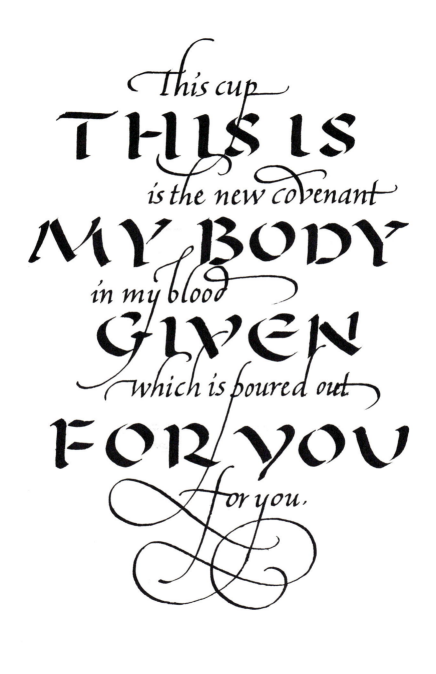

DEATH IS SWALLOWED UP IN

Victory

from 1 Corinthians 15:54 NIV

We are hard pressed
on every side,
but not crushed;
perplexed,
but not in despair;
persecuted,
but not abandoned;
struck down,
but not destroyed.

2 CORINTHIANS 4:8-9 NIV

THEREFORE
IF ANYONE
IS IN CHRIST
HE IS A NEW
CREATION
THE OLD
HAS GONE
THE NEW
HAS COME!

2 CORINTHIANS 5:17 | NIV

WE TAKE CAPTIVE

every thought *every thought* every thought

EVERYTHOUGHT

every thought

EVERY THOUGHT

every thought

EVERY THOUGHT

every thought

EVERY THOUGHT

TO MAKE IT OBEDIENT TO CHRIST

—from 2 Corinthians 10:5 NIV

Praise be to the God and Father of our Lord Jesus Christ

WHO HAS BLESSED US IN THE HEAVENLY REALMS WITH EVERY SPIRITUAL BLESSING IN CHRIST.

EPHESIANS 1:3 NIV

FOR HE CHOSE US
IN HIM BEFORE
THE CREATION
OF THE WORLD
TO BE HOLY
AND BLAMELESS
IN HIS SIGHT.

EPHESIANS 1:4 NIV

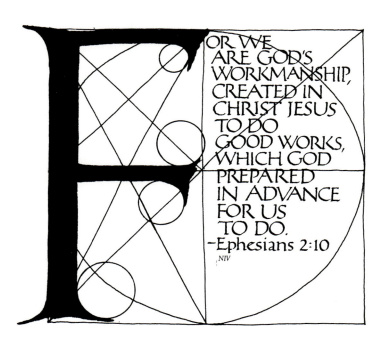

FOR WE
ARE GOD'S
WORKMANSHIP,
CREATED IN
CHRIST JESUS
TO DO
GOOD WORKS,
WHICH GOD
PREPARED
IN ADVANCE
FOR US
TO DO.
—Ephesians 2:10
NIV

YOU
WHO
ONCE
WERE FAR
AWAY
HAVE BEEN
BROUGHT NEAR
THROUGH THE
BLOOD OF
CHRIST

from EPHESIANS 2 : 13 NIV

over

ONE BODY

all

ONE SPIRIT

and

ONE HOPE

through

ONE LORD

all

ONE FAITH

and in

ONE BAPTISM

all

ONE GOD AND FATHER OF US ALL

from Ephesians 4:4–6 NIV

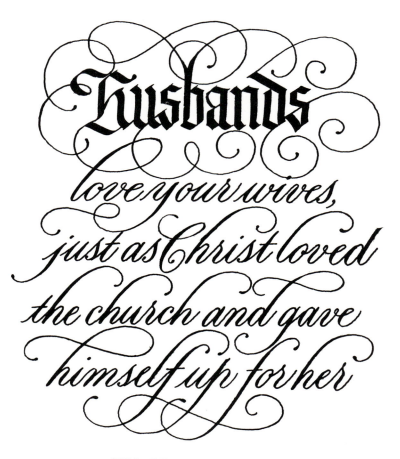

Husbands love your wives, just as Christ loved the church and gave himself up for her

EPHESIANS 5 : 25 NIV

HONOR YOUR FATHER AND MOTHER that it may go well with you and that you may enjoy long life on the earth

from Ephesians 6=2,3 NIV

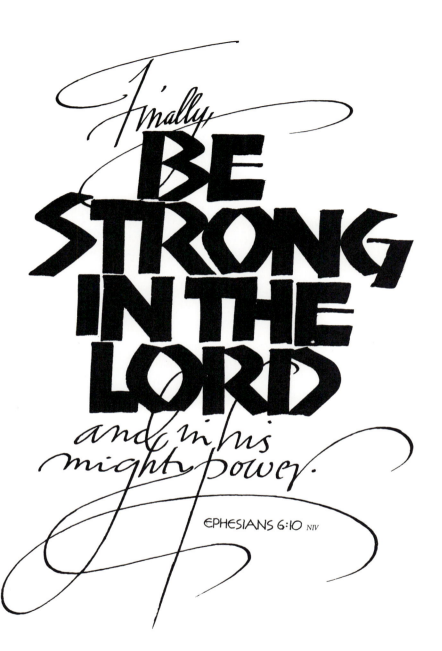

Finally

BE STRONG IN THE LORD

and in his mighty power.

EPHESIANS 6:10 NIV

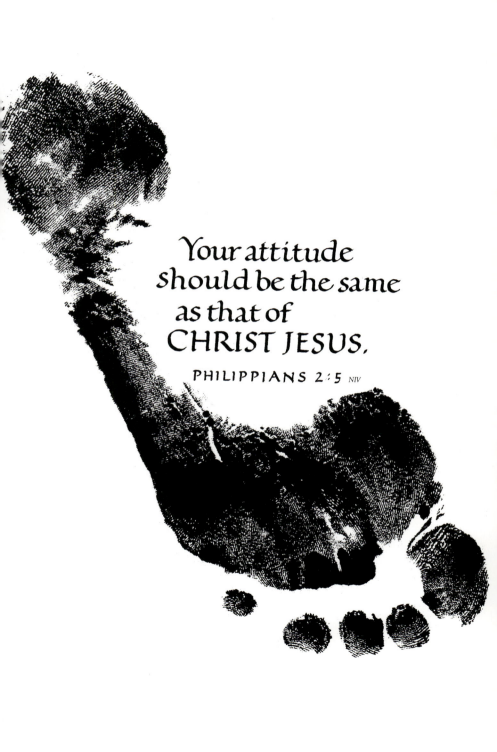

Your attitude
should be the same
as that of
CHRIST JESUS,

PHILIPPIANS 2:5 NIV

I CONSIDER
EVERYTHING
A LOSS
COMPARED
TO
THE

*surpassing
greatness*

OF
KNOWING
CHRIST JESUS
MY LORD.

from Philippians 3:8 NIV

I PRESS ON TOWARD THE GOAL TO WIN THE PRIZE FOR WHICH GOD HAS CALLED ME HEAVENWARD IN CHRIST JESUS PHILIPPIANS 3:14 NIV

Don't be anxious
about anything,
but in everything,
by prayer and petition,
with
Thanksgiving,
present your requests
to God,

PHILIPPIANS 4 : 6 NIV

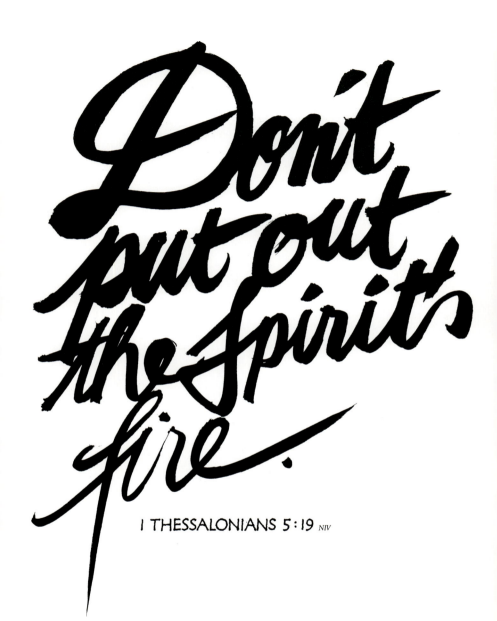

1 THESSALONIANS 5:19 NIV

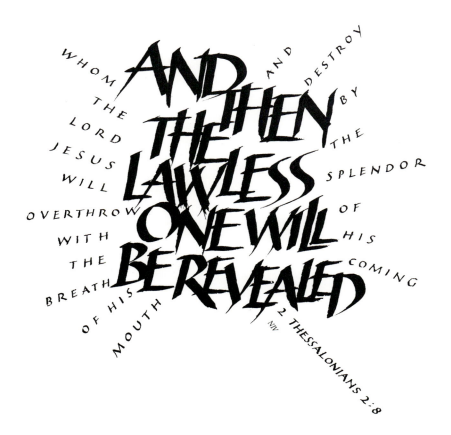

AND THEN THE LAWLESS ONE WILL BE REVEALED WHOM THE LORD JESUS WILL OVERTHROW WITH THE BREATH OF HIS MOUTH AND DESTROY BY THE SPLENDOR OF HIS COMING

2 THESSALONIANS 2:8 NIV

MAY THE LORD DIRECT YOUR HEARTS INTO

God's love &

Christ's perseverance

God's love &

Christ's perseverance

God's love &

Christ's perseverance

God's love &

Christ's perseverance

2 THESSALONIANS 3:5 NIV

Don't let anyone
look down on you
because you are young,
but set an example
for the believers
in SPEECH, in LIFE,
in LOVE, in FAITH
and in PURITY.

1 Timothy 4:12 NIV

from 2 Timothy 2:2 NIV

...from infancy
you have known
the holy Scriptures,
which are able to
make you wise
for salvation
through faith
in CHRIST JESUS.

2 TIMOTHY 3:15 NIV

WITHOUT FAITH
IT IS IMPOSSIBLE
TO PLEASE GOD
BECAUSE ANYONE
WHO COMES TO HIM
MUST BELIEVE
THAT HE EXISTS
AND THAT HE
REWARDS
THOSE WHO

earnestly

SEEK HIM
HEBREWS 11 : 6

NIV

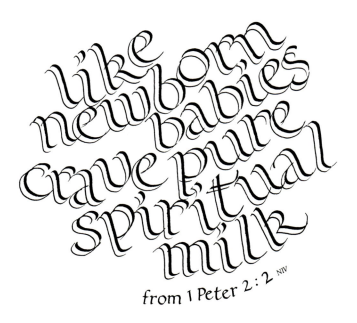

like newborn babies crave pure spiritual milk

from 1 Peter 2:2 NIV

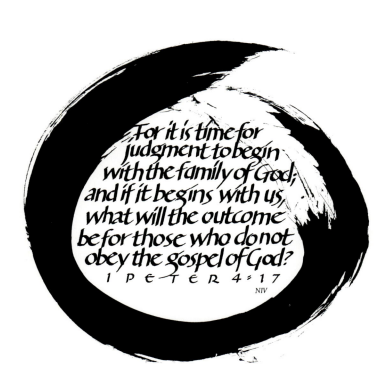

For it is time for
judgment to begin
with the family of God;
and if it begins with us,
what will the outcome
be for those who do not
obey the gospel of God?
1 PETER 4:17
NIV

To him who loves us
and has freed us

from
REVELATION
1:5 & 6
NIV

from our sins
by his blood,
and has made us
to be a kingdom
and priests to serve
his God and Father
To him be glory
and power
forever

PRAISE OUR GOD,
ALL YOU HIS SERVANTS,
YOU WHO FEAR HIM,
BOTH small AND
GREAT

REVELATION 19:5 NIV

INDEX